LOCUS

catch 014

光合作用

作者：張妙如

英譯：Matt McCabe

責任編輯：韓秀玫

美術編輯：何萍萍

法律顧問：全理法律事務所董安丹律師

出版者：大塊文化出版股份有限公司

台北市105南京東路四段25號11樓

www.locuspublishing.com

讀者服務專線：0800-006-689

TEL：(02)87123898　FAX：(02)87123897

郵撥帳號：18955675

戶名：大塊文化出版股份有限公司

e-mail:locus@locuspublishing.com

行政院新聞局局版北市業字第706號

版權所有 翻印必究

總經銷：北城圖書有限公司

地址：台北縣三重市大智路139號

TEL：(02)29818089 （代表號）

FAX：(02)29883028　29813049

製版：源耕印刷事業有限公司

初版一刷：1998年6月

初版二刷：2002年1月

定價：新台幣250元

ISBN 957-8468-42-3

Printed in Taiwan

●目錄1

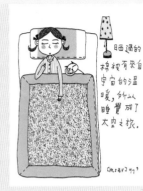

這兩週的棉被有來自宇宙的溫暖，所以睡覺成了太空之旅。

本該飄落在L.A.的銀杏樹葉，自朋友的來信中跌了出來，飄落在我家地上，那一剎那我的地和L.A.的土地交換了一小塊。

●目錄 2

●目錄3

宇宙太空被

Our cover has been sunbathing
all day long.
It has the heat of the Cosmos
and tonight it will take us there.

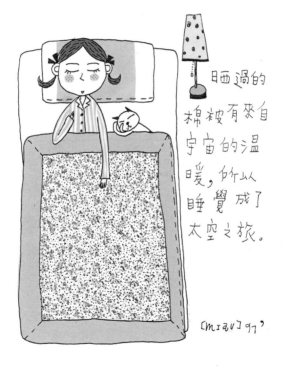

晒過的
棉被有來自
宇宙的温
暖,所以
睡覺成了
太空之旅。

寫字療法

I treat you like a wound.
I write your name on my arm
and cover it with a bandage.
It's like you were a secret in my heart.
Once your name fades away,
I will be healed.

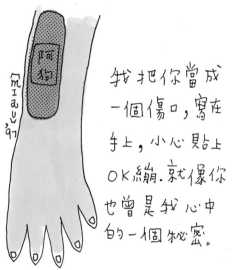

我把你當成
一個傷口，寫在
手上，小心貼上
OK繃.就像你
也曾是我心中
的一個祕密。

字跡淡去的那天，我
想也会是傷口痊癒的日子。

巴黎心

I've set my clock to the time of
my favorite place.
Everything I do in my day follows
their day. Oh, how romantic!
I can have a day in Paris
when I'm in Taipei!

我把自己的手錶，
調成喜歡的國家
的時間。

然後照那個時
間作息一天。

啊！多令人感動，
我在台灣過了
一天巴黎！

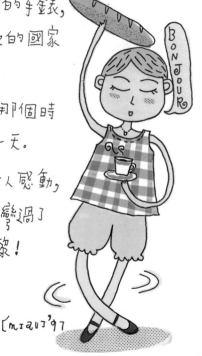

小王子

Each book is a world unto itself.
Sometimes I'm like "The Little Prince"
and I can travel to different worlds and
planets.

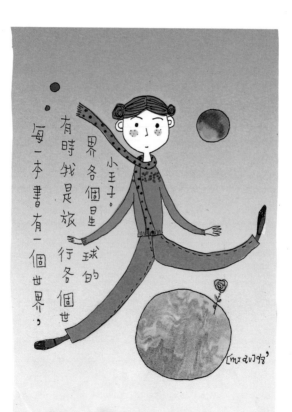

每一本書有一個世界，有時我是旅行各個世界各個星球的小王子。

寫信的藉口

Today, I didn't finish my work
so I've separated part of my work
and mailed it to myself.
Tomorrow I'll find out
if I can help myself!

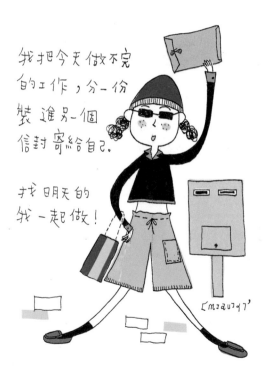

心膨脹了

When I feel sorrowful,
my heart grows bigger and bigger
until it gets stuck in my throat
and I can't say a thing.

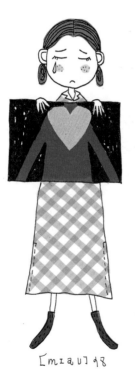

難過時，

心脹大了，

哽在喉嚨

裡，

說不出話。

[mɪaʊ] 98

等待小叮噹

I'm painting a door inside my desk drawer, so Toraemon will come secretly to visit me.

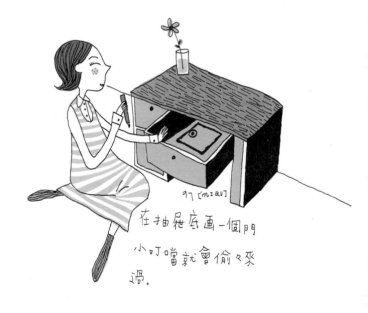

97 [miau]

在抽屜底畫一個門
小叮噹就會偷々來
過.

陽光印泥

This window is a chop
and the morning sunshine is ink.
The chop and the ink combine to
print this harmonious scene.

這一方窗子像印章，早晨的陽光是
印泥，印出窗裡這一方動人的景
像。

[miall]'48

突然哭了

Ocean waves suddenly froze
and turned into mountains.
My heart suddenly melted
and turned into tears.

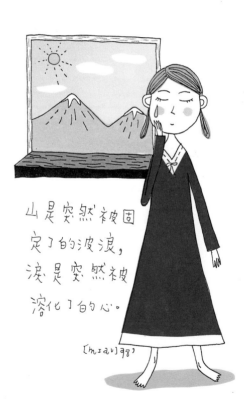

山是突然被固
定了的波浪，
浪是突然被
溶化了的心。

〔m：a：i，98〕

蛋糕超人

Today, the cake and I become one.
We are Supper Woman.

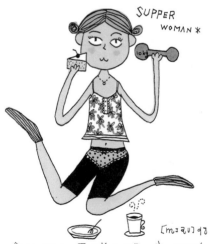

今天我和蛋糕合體，變成有活力
的超人。

水的問候

This glass of water has travelled
over the earth and through the sky.
It has the taste of clouds.
So I drink it and let the clouds
float throughout my body.
They can go where I can't.

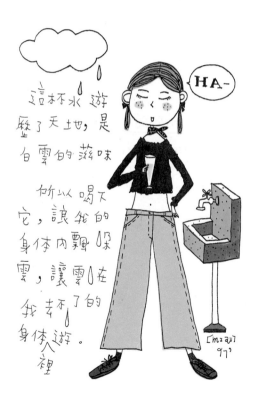

Taxi-radio

*Sometimes the radio can transport you
somewhere else.
When you listen to a radio program,
you feel like you're riding in a taxi.*

收音機有時會令人 瞬間
移動。就像 ~~有時~~ 收聽到
某些節目就有 坐計程車
的感覺～

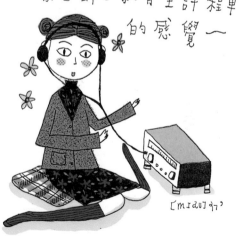

今天天氣真好

At night, blackness erases yesterday's me.
Today, the rays of the sun recreate me.

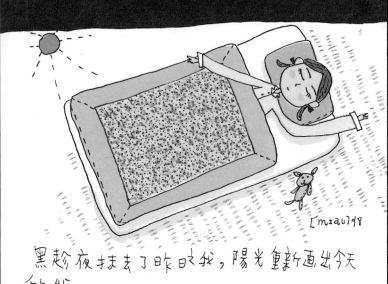

黑趁夜抹去了昨日我，陽光重新畫出今天的我。

天空之城的繼承人

If possible, you can paint a deep blue sky
and cotton white clouds on your wall
and imagine that you live in a sky city.

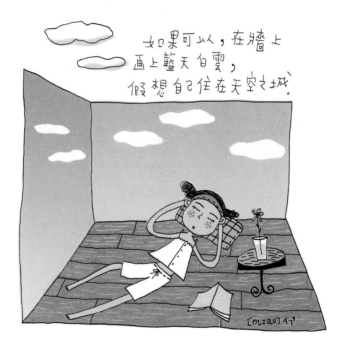

如果可以，在牆上
畫上藍天白雲，
假想自己住在天空之城。

[mɪaʊ]彤

50元可以快樂2次

The clerk overpaid me $50 NT in change
so I'm happy to get some free money.
Later, I returned the $50 NT to the clerk
and I feel happy once more.
Isn't it amazing how $50 NT
can make me feel happy twice?

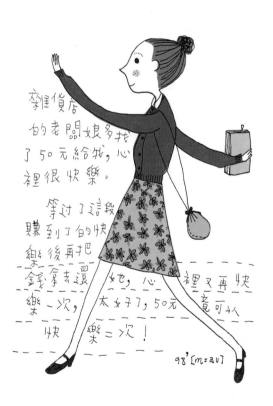

雜貨店
的老闆娘多找
了50元給我，心
裡很快樂。

　　等過了這段
賺到了的快
樂後再把
錢拿去還她，心裡又再快
樂一次，太好了，50元竟可以
快樂二次！

98'[m=aʊ]

我是L.A.小地主

This gingko leaf
should have fallen down in L.A.
but instead it fell out of my friend's
letter and onto my floor.
At that moment,
my floor and L.A. exchanged places.

本該飄落在 L.A.
的銀杏樹葉，自朋友
的來信中 跌了出來，
飄落在 我家地上

那一剎那 我家的
地和 L.A. 的土地交
換了一小 塊。

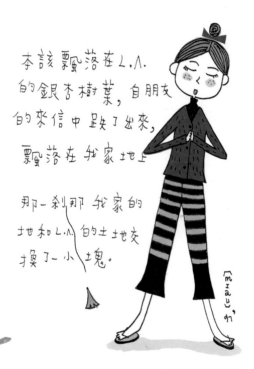

和往事握手

I mailed to myself
your old love letters to me.
So I return to the past.

我把你從前寫給我的信　一封一封
重新寄給自己　就好像
我又回到了從前的那個 時候...

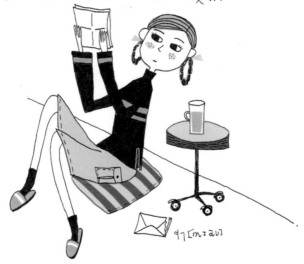

好想中個獎

My life is hopeful.
Every time I buy something,
I get a receipt and I have a chance.

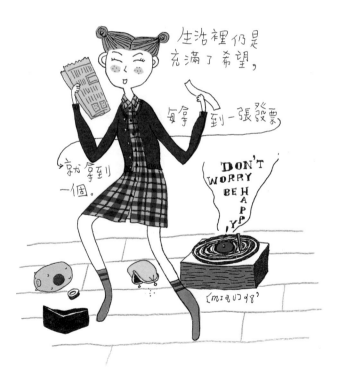

眼淚書夾

Laughter and tears are the bookmarks
of my life.
They mark the pages I have lived through.

笑 和淚　　都是我人生的書夾，夾
　　　　　　在某一頁當中。

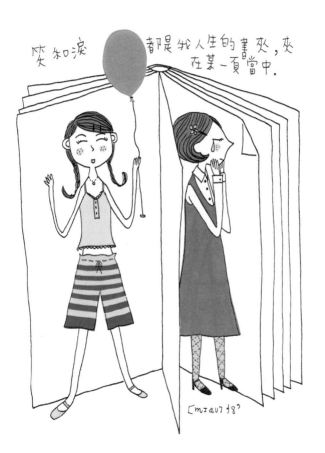

[miau] 98'

邂逅

Maybe this flower will only meet me
once in its life.

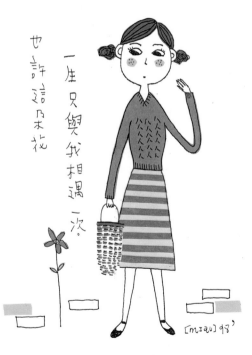

一生只與我相遇一次。

也許這朵花

Cat's eyes

When the cat looks at me,
I am reflected in two amber frames.

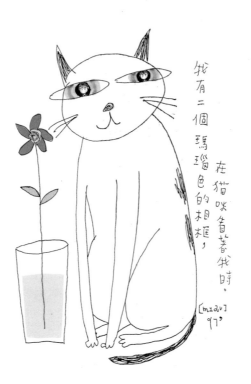

我有三個瑪瑙色的相框，在貓咪看著我時。

[miau]
97'

去7-11 Shopping日本

Today, I am going to Japan.
I'm going to eat Japanese snacks
and drink Japanese tea.
I'm going to the 7-11 to buy those things
and come back to watch
Japanese TV shows.

今天我要去日本，
吃日本的零食 喝日本
的茶，去便利
商店買，

回來看日
本的節目。

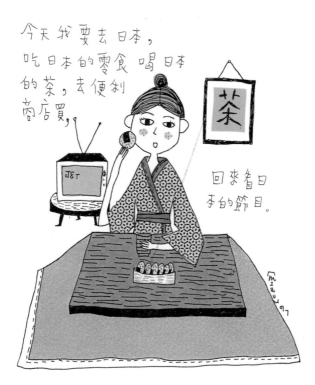

磁磚牌大富翁

My friend plays real Monopoly

on her floor tiles at home.

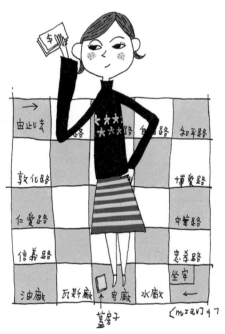

朋友利用家裡地板的磁磚
玩真人活動大富翁.

我讓我演我

There's a computer game of virtual reality
where many people are reborn
and some control their roles.
Sometimes I think maybe in real life
I'm just the person who controls my body
in this world to play the role of myself.

在電腦的連線 PC GAME 中
有一個虛擬的世界，有許多人在
那裡誕生，在那裡操縱某個角色。

有時我會　　　　　想，也許真實的
人生我不過　　　　是在操縱自己的肉
体，在這個　　　　　世界扮演「我這個
角色。

太空旅行1小時

Sometimes I travel to Outer Space.
At the Shihlin Observatory,
I get into a spaceship, leaving the Earth
at lightspeed to return one hour later.

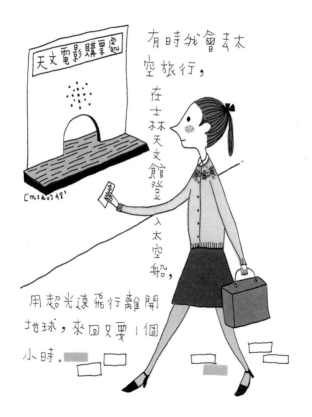

有時我會去太空旅行，在士林天文館登入太空船，

天文電影購票處

[miau] 18'

用超光速飛行離開地球，來回只要1個小時。

生氣可以壯膽

Anger has something good about it.
It makes people forget their fears.

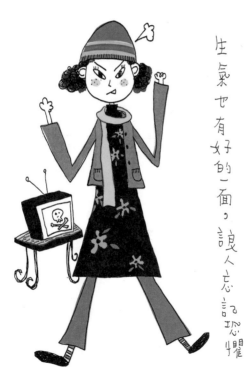

生氣也有好的一面，讓人忘記恐懼

（幾米）98.

上帝的風景畫

The window is the frame for scenery.
If there is a window,
you can see a picture from God.

窗戶為風景裱框，只要有窗就
有一幅上帝的畫。

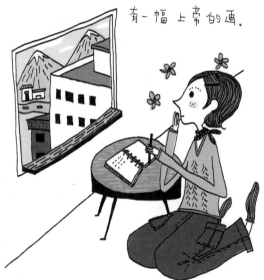

〔miau〕98

神奇時差魔法師

I call my friend who lives overseas.
I tell her I took a shower at 9:08 pm.
It's earlier where she lives,
so I make her a prophetess.

打電話給在遠方的友人，
告訴她，我在她還沒遇到的
晚上9：08時　洗了個澡，
　　　　　　說她當個
　　　　　　先知。

懶懶的，懶懶的我

When I wake up in the early morning,
I feel lazy.
My room becomes a fish bowl,
my blanket is water and I swim slowly.

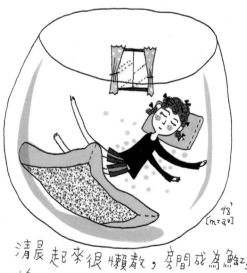

清晨起來很懶散，房間成為魚缸，
棉被是水，我懶懶的游。

抽一口傷心煙

Write on a cigarette

whatever it is that has broken your heart.

Then light the cigarette

and let it blow away with the smoke.

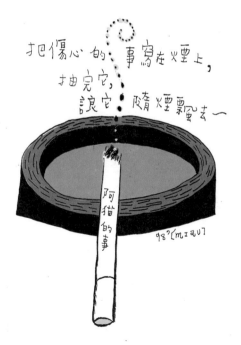

隱形黑人

When the lights are off, I wear black.
I'm invisible, no one can see me at all.

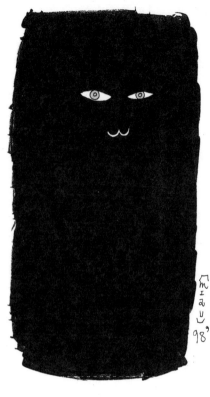

只要關上燈，我就穿上黑暗，我就可以隱形。

影子不怕痛

I'm angry with myself
so I punch my shadow.

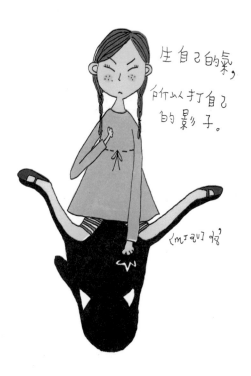

生自己的氣，
所以打自己
的影子。

聲音的旅行

Today my voice wants to fly
through the air to Taichung.
So I call a friend who lives there
on the phone.

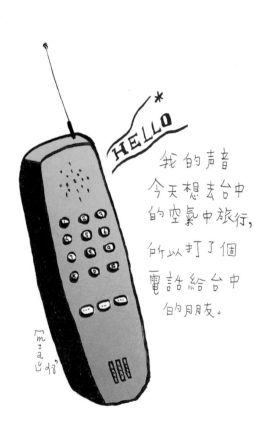

* HELLO

我的声音
今天想去台中
的空氣中旅行,
所以打了個
電話給台中
的朋友。

暖暖貓

In winter, my cat is my live heater.

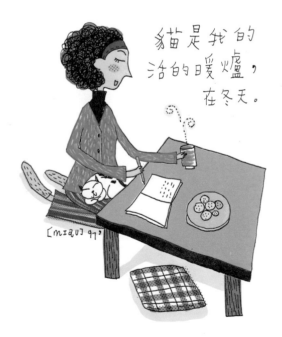

貓是我的
活的暖爐，
　在冬天。

天空與我同行

Wherever I go every day,
I carry the sky with me.

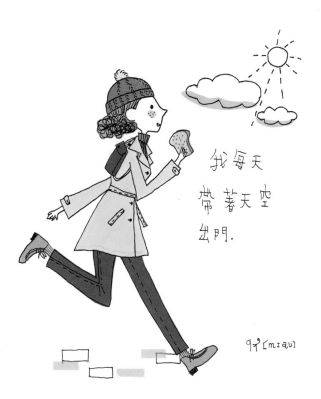

我每天
帶著天空
出門.

ㄇㄧㄠ [miau]

風情玻璃罐

Put your picture into an old jar.
What a curious frame.

用玻璃罐當相框，別有一種風情。

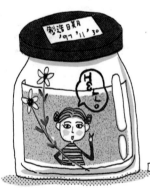

一輩子

It's not so bad! Nothing lasts forever.
Happiness doesn't last forever.
Pain also doesn't last forever.
Time is cruel but it's not so bad
because it passes quickly.

還好，沒有什麼
是永遠的，

↓↑

快樂不能永遠，

↓↑

痛苦當然也無法

↓↑

時間流逝很殘酷，
但還好它会流逝。

[mɪav]98

洗洗樂

Sometimes the bathtub is my bed
and hot water is my cover.
It can cure my fatigue like a real bed.

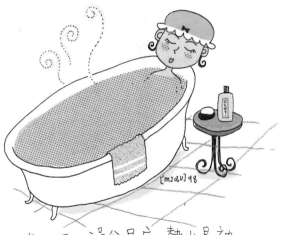

有時候，澡盆是床，熱水是被，
為我解除同樣的疲累。

雲裡游

On the swimming pool,
there is a reflection of blue sky
and white clouds so I think to myself
I'm swimming in the sky.

因為游泳池裡有藍天
白雲的映影，所以我以為
自己在天空中的白雲裡游。

[MIAU] 97'10

換裝

I wear colored contact lenses
as well as clothing and a hairstyle
that belongs to someone else.
When I walk down the street,
I pretend I am another person
with a different life.

只要一副角膜變色片，
一身不是花蛋格的
衣，再變個頭
髮。
　走在街行上，我
　就可以假裝我
是另一個人，過著
另一種人生～

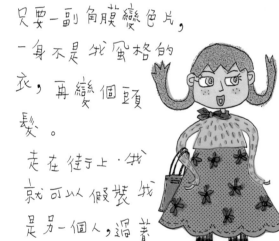

[MIQU]'97

好書福

When I'm asleep, I dream of a dream
soaked in the smell of old books.

睡著了，
夢裡襯的
是老書
的
潮味。

貓咪搶走陽光

My cat cuts a piece of sunshine
for its blanket.

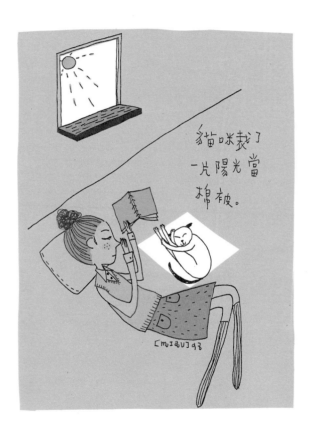

貓咪裁了
一片陽光當
棉被。

[mɪaʊ] 98

脫離地球的方法

At an unconventional library,
I borrow a book
that many people have borrowed before.
So all its readers have
at different times and places
entered the same virtual reality world.

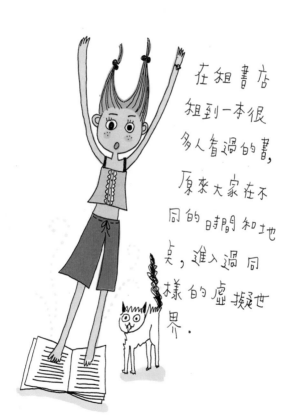

在租書店
租到一本很
多人看過的書,
原來大家在不
同的時間和地
點,進入過同
樣的虛擬世
界。

歷史娃娃

This doll is a memory machine.
Every time I see her,
I remember old times.
She records the past.

這個娃娃是個記錄器，

每次看到它就令我想起了那段時光，

它記憶了我那個時刻。

[miau]'98'

託日出捎個信

I pray a blessing for you at sunrise
because a few hours later
the sun will bring this blessing to
faraway you.

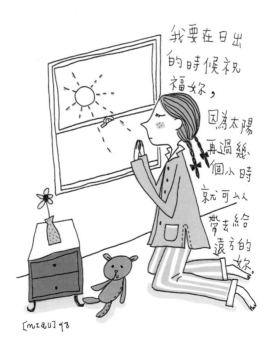

我要在日出
的時候祝
福妳，

因為太陽
再過幾
個小時
就可以
帶去給
遠方的
妳。

[MIAU] 98

魚缸聯想曲

It's wonderful, my clear glass table
with a fish tank underneath.
I can read a book,
drink tea and gaze at my fish
all at the same time.

真是太好了，
我的桌子玻璃下
養了一缸魚，
我可以邊喝茶，
邊看書，邊看魚。

[mɪaʊ dʒ]

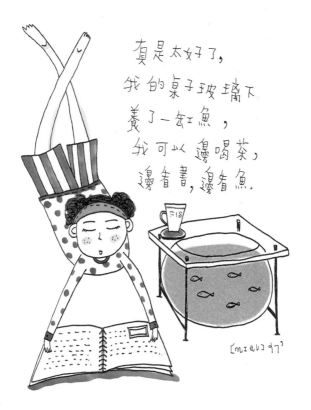

盆地神話

Taipei basin is a water basin.
The sky has a face of water.
The city below the water
is like a fantastic palace.

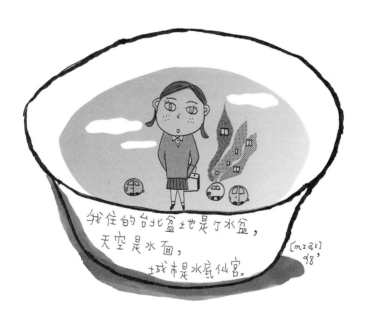

我住的台北盆地是个水盆，
　天空是水面，
　　　城市是水底仙宫。

[mzavi]
'98'

散步塗鴉

I was thinking that I was once in my house,
walking with my cat
and painting on the wall
as we went along.

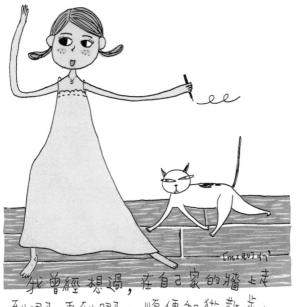

我曾經想過，在自己家的牆上走
到哪，畫到哪，順便和貓散步。

改變世界很簡單

Everyone is on a ship called "Earth"
and it's in perpetual motion.
We travel on it through the Universe.

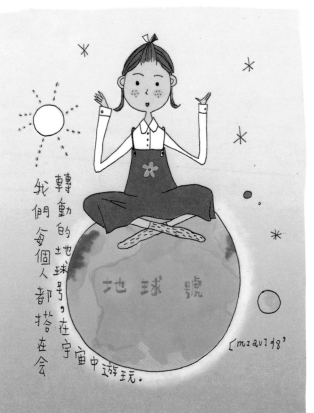

轉動的地球號，在宇宙中遊玩。
我們每個人都搭在會

一天的魅力

Life is so amazing as each day
you can see the future.
Every single day you have the chance
to meet somebody new
walking along the street.

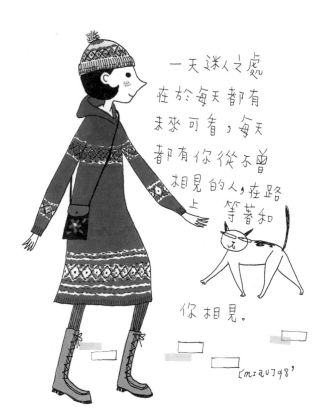

一天迷人之處
在於每天都有
未來可看，每天
都有你從不曾
相見的人，在路
上　等著和

你相見。

[miau]98'

地球、地球放光明

I bought a globe that lights up.
When my room is dark,
the glowing globe floats
and the room is a mini-cosmos.

買了一個會發亮的地球儀，只要房間的燈一關，它就浮在黑暗中，我的房間就是一个小宇宙。

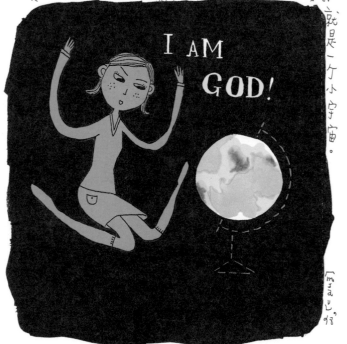

消氣床

When I'm afraid or angry,
I let my bed hold me in its mouth.
Sleeping can sometimes be
a transportation machine for the emotions.

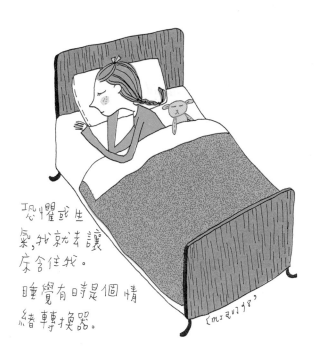

恐懼或生
氣，我就去讓
床含住我。
睡覺有時是個情
緒轉換器。

看見貓咪

My cat sends sunshine t hrough
the cracks in my sleep-closed eyes.
The sunshine then opens up my doors
from the inside.

猫咪派陽光從我眼睛的縫
隙溜進來，從內打開我關好
的門戶。

老錢

This money is older than me.
I need to use it for something urgent
and I feel warm inside.

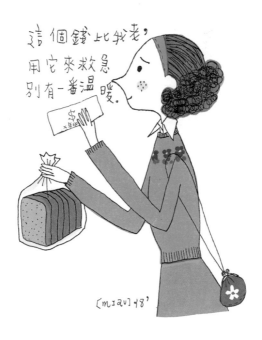

回到過去未來人

In my mother's old suitcase,
I found some clothes and money of hers. When
she was young,
she wore these kinds of clothes
and used this money.
I put on her old clothes and go for
a walk with her old money.
I'm transported in a time machine
from 30 years ago into the modern city.

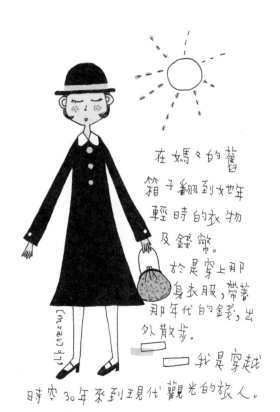

在媽々的舊
箱子翻到她年
輕時的衣物
及錢幣。
於是穿上那
身衣服,帶著
那年代的錢,出
外散步。

—— 我是穿越

時空 30 年 來到現代 觀光的旅人。

種黃金葛想你

I planted this creeper so that every day
it will grow more and miss you
instead of me missing you.

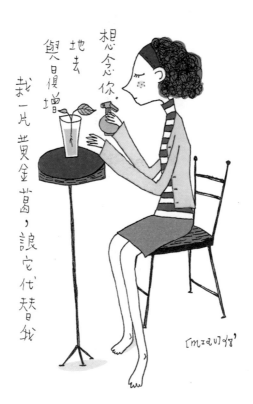

想念你，
地去
與日俱增

栽一片薄荷金萱，讓它代替我

[miau]98'

眼睛是静物畫

My eyes are uncomfortable
and I'm in a bad mood.
So I put on my glasses
and I discover that God has sent me
two pictures in frames.

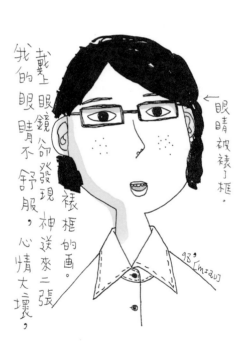

眼睛被裱了框。

裱框的画。

戴上眼鏡爺爺發現神送來二張，我的眼睛不舒服，心情大壞，

98° [miau]

讓痛苦打敗痛苦

Sometimes pain needs another pain
to relieve it.

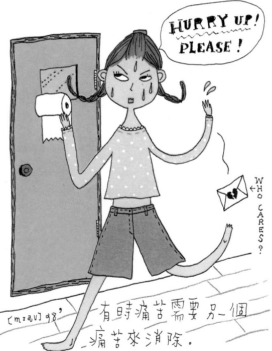

[mɪaʊ] 98'　有時痛苦需要另一個
痛苦來消除。

友情最美麗

Each friend is a drawer.
Inside there's a treasure
that no one knows
and there is also a part of me.

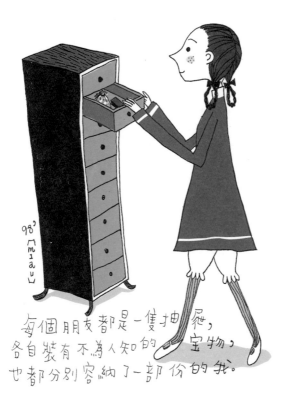

每個朋友都是一隻抽屜，
各自裝有不為人知的　宝物，
也都分別容納了一部份的我。

傷心帶我去散心

When I feel hurt,
my heart breaks so I go travelling.
That makes heartbreak not so bad.

我的傷心
也會帶我去
旅行，傷
心沒什麼
不好。

WELCOME
內心世界

四度空間小口袋

I close my eyes
and the darkness is limitless.
That's my four-dimensional pocket
where I can keep everything.

閉上眼，黑暗無限大，月陨我
四度空間的口袋，永遠放得下我
的雜物。

跳一跳，笑一笑

I want to leave the Earth for a moment--
so for a second I jump up in the air.

想離開地球，
所以跳了一下。

[miqu] 98'

找不到淚滴的地方

If you're feeling really sad,
turn your sad story into teardrops.
Then shed your tears
drop by drop into the sink.
They'll flow to a place
where you'll never have to see them again.

它就能去到你再也找不到的地方。

只要把淚一滴一滴丟入洗手台的排水孔中，

真的難過，那就把傷心的事用眼淚分裝，

照片的獨白

A picture is an icebox of time and space.
At that very moment, that second,
I step into the picture
and never ever change.

照片是個時空凝結箱，在那一刻，那一秒，再改變，我進入了照片裡就永遠不

[m=2v]
'98

破壞很簡單

I was really furious
so I decided to destroy the Earth.
I carried a shovel and I dug a small hole
in my garden.
HA-HA! I've finally destroyed the Earth.

洞，哈！哈！地球果然被我破壞了。

拿了鏟子在空地上挖了一個小

因為太生氣，決定去破壞地球，

一部份。
地球
↓

[mːㄐ ㄓ] 98'

假裝喝醉

When I'm upset,
I plant myself in the sofa.
I watch TV or read comic books
to inhale fresh air
and exhale deadly depression.

心煩時，把自己種在舒
服的沙發裡，
不論是對著電視或漫畫，
盡情吸取生氣，完全釋放
喪氣。

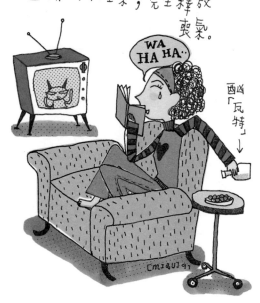

酗「瓦特」→

開心燈

I've installed a wall lamp.
Whenever I turn it on,
sunshine visits me as my guest.

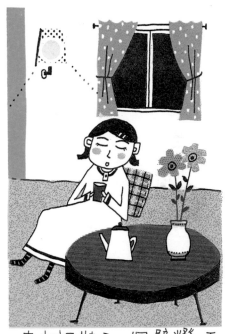

在家裡裝了一個壁燈，不
管什麼時候，只要一開，太陽
就被請進了家裡做客。

收到雨

Maybe I can tell the water in the bowl
how I miss you, then put it outside so the
sun will evaporate it.
When it rains,
you will receive my yearning message.

或許我可以
把想念
說進水裡，
放在有陽
光的地方，
讓太陽把水
蒸發。

在下次下
雨時，你可
以收得到。

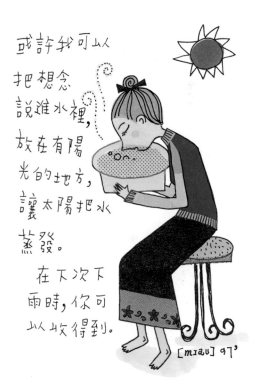

[miau] 97'

打電話給貓

My friend has a cat with a big face
and his name is Hello Kitty.
I call her on the phone
and ask for Hello Kitty.
Does she think her life
is different from other cats?

朋友家養了一隻
叫 HELLO KITTY 的
大頭貓。
於是我打電話
去找牠：
「喂，HELLO KITTY 在
家嗎？」
呵！牠会不会因此而
感到牠的
《猫生》是不同
的？

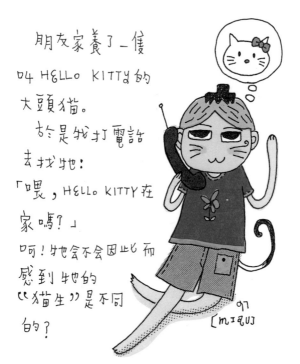

97
[miau]

相信

I wrote two characters for "Success"

on my palm.

HA-HA!

Victory is now in hand.

哈哈 勝利掌握在手中！

在手掌心寫下成功，

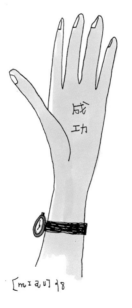

成功

[mɪəʊ] 98

國家圖書館出版品預行編目資料

光合作用／ 張妙如著 . — 初版 . — 臺北市：
大塊文化，1998〔民 87〕
面； 公分 . — (Catch；14)
ISBN 957-8468-42-3 (精裝)

851.8 87001226

大塊文化出版股份有限公司　收

地址：_____市／縣_____鄉／鎮／市／區_____路／街
_____段_____巷_____弄_____號_____樓
姓名：

LOCUS

LOCUS

LOCUS